THE
draw
ANY
animal
BOOK

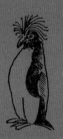

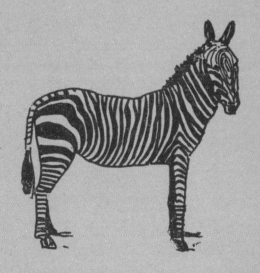

THE
draw
ANY
animal
BOOK

Over 150 simple step-by-step drawing sequences for every kind of creature

ROBERT LAMBRY

QUARRY

Inspiring | Educating | Creating | Entertaining

Brimming with creative inspiration, how-to projects, and useful information to enrich your everyday life, Quarto Knows is a favorite destination for those pursuing their interests and passions. Visit our site and dig deeper with our books into your area of interest: Quarto Creates, Quarto Cooks, Quarto Homes, Quarto Lives, Quarto Drives, Quarto Explores, Quarto Gifts, or Quarto Kids.

First Published in 2019 by Quarry Books,
an imprint of The Quarto Group,
100 Cummings Center, Suite 265-D,
Beverly, MA 01915, USA.
T (978) 282-9590 F (978) 283-2742
QuartoKnows.com

10 9 8 7 6 5 4 3 2 1

ISBN: 978-1-63159-841-8

Library of Congress Cataloging-in-Publication Data is available.

Conceived, edited, and designed by
Quarto Publishing plc, an imprint of
The Quarto Group
The Old Brewery
6 Blundell Street
London N7 9BH

QUAR.328359

Art director: Gemma Wilson
Editorial assistant: Charlene Fernandes
Designer: Kate Wiliwinksa
Copy editor: Sarah Hoggett
Senior commissioning editor: Eszter Karpati
Publisher: Samantha Warrington

Printed in China

table of contents

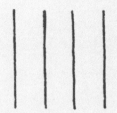

Straight
parallel lines

Curved lines

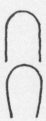

Arches

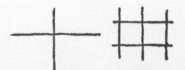

Perpendicular lines

Angles

Spirals

Broken line

Pointed arch

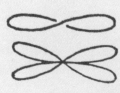

Helixes

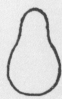

Pear

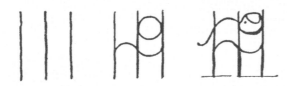

11

Parallel line example:
Dog

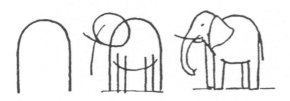

12

Arch examples:
Elephant

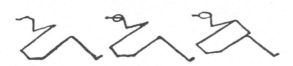

13

Angle example:
Stork

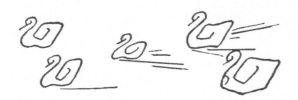

14

Spiral example:
Duck

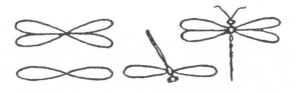

15

Helix example:
Dragonfly

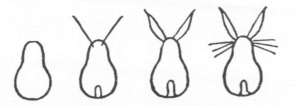

16

Pear example:
Rabbit

The previous page taught us about the uses we can get from the knowledge of geometric lines to represent animals; simple shapes will be equally helpful.

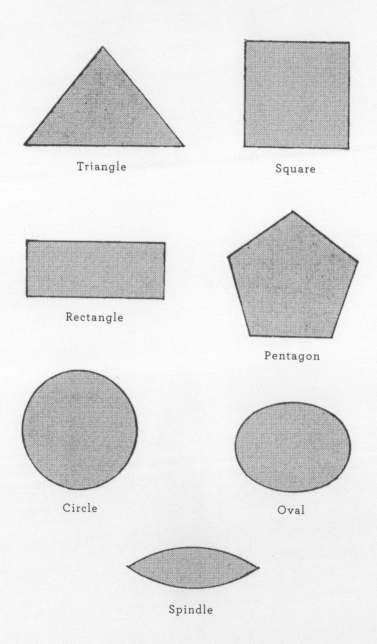

Triangle

Square

Rectangle

Pentagon

Circle

Oval

Spindle

8

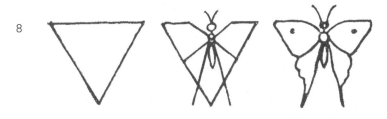

Triangle example: Butterfly

9

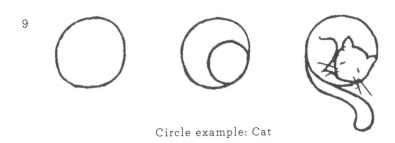

Circle example: Cat

10

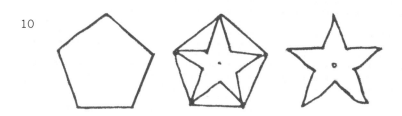

Pentagon example: Starfish

11

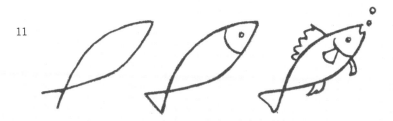

Spindle example: Fish

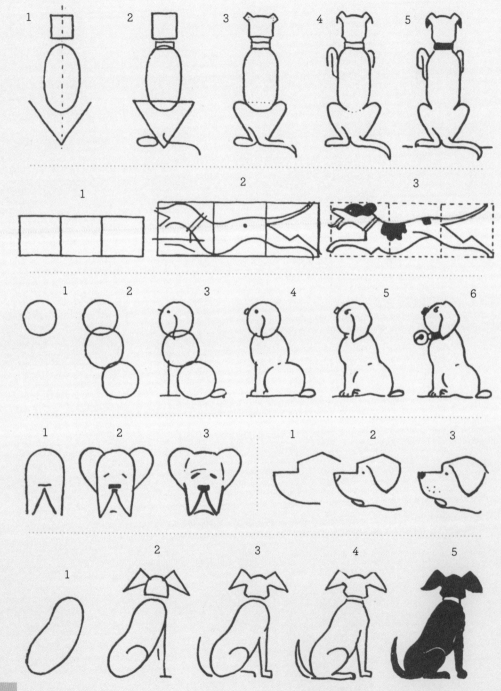

Now you have a go!

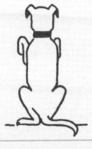

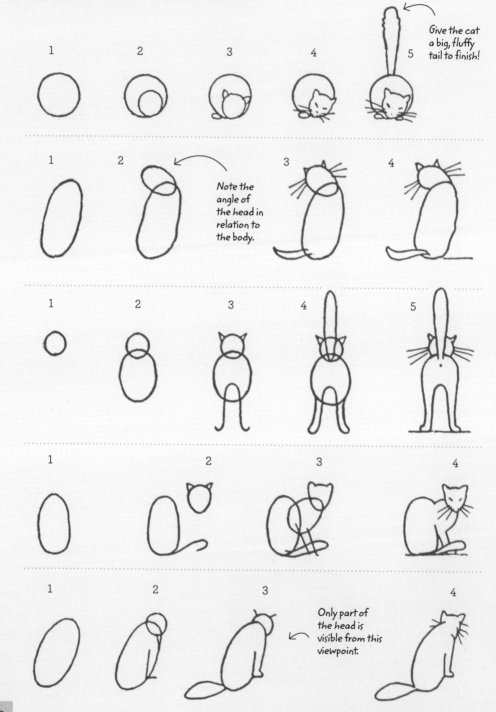

Give the cat a big, fluffy tail to finish!

Note the angle of the head in relation to the body.

Only part of the head is visible from this viewpoint.

Now you have a go!

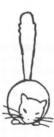

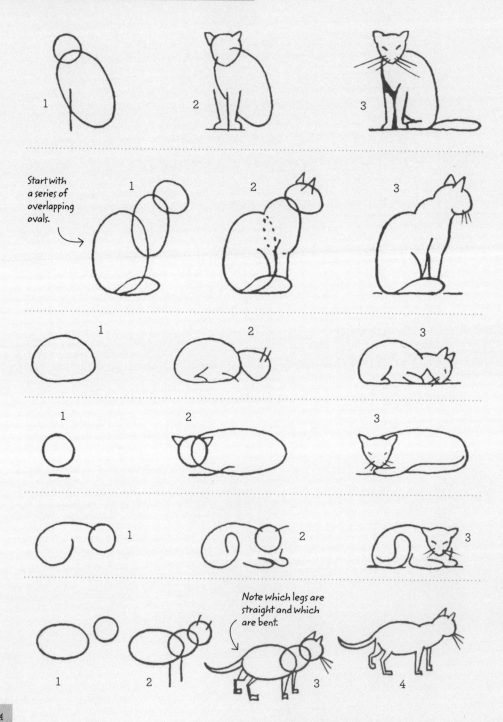

Start with a series of overlapping ovals.

Note which legs are straight and which are bent.

Now you have a go!

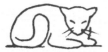

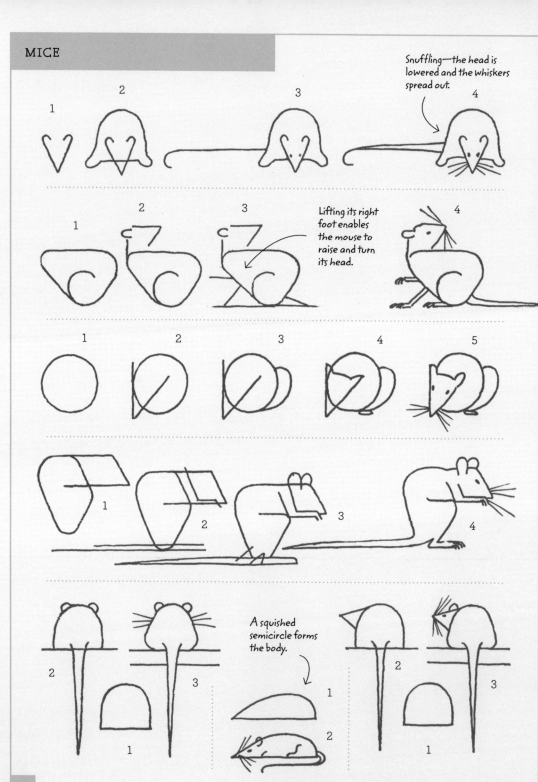

Snuffling—the head is lowered and the whiskers spread out.

Lifting its right foot enables the mouse to raise and turn its head.

A squished semicircle forms the body.

Now you have a go!

RATS

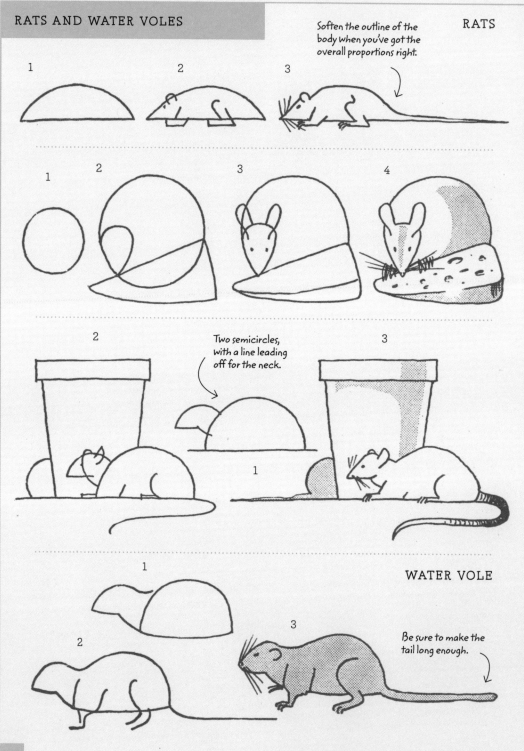

Soften the outline of the body when you've got the overall proportions right.

1 2 3

1 2 3 4

Two semicircles, with a line leading off for the neck.

2 1 3

WATER VOLE

1

2 3

Be sure to make the tail long enough.

Now you have a go!

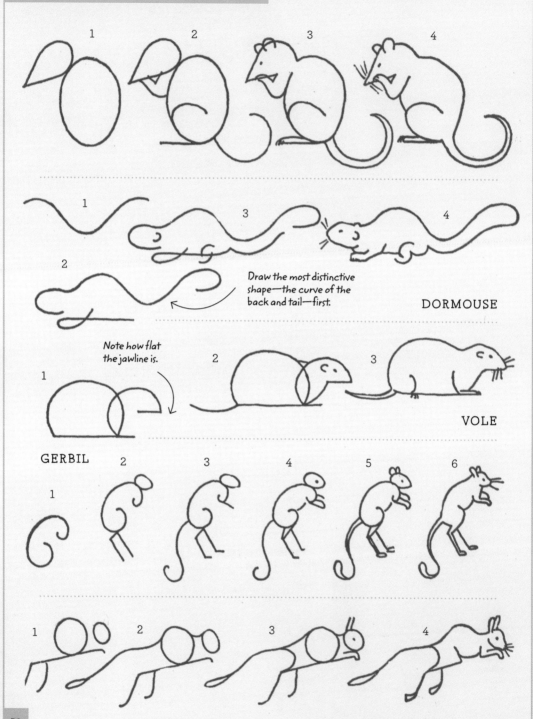

Draw the most distinctive shape—the curve of the back and tail—first.

DORMOUSE

Note how flat the jawline is.

VOLE

GERBIL

Now you have a go!

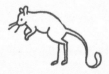

Look at the "negative shape" between the snout and foreleg.

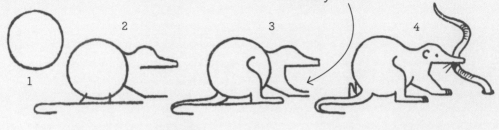

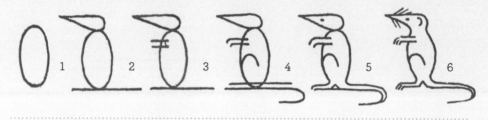

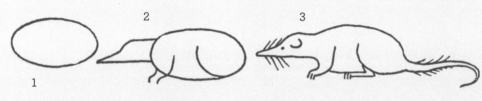

As the animal moves forward, its far hind leg is straightened.

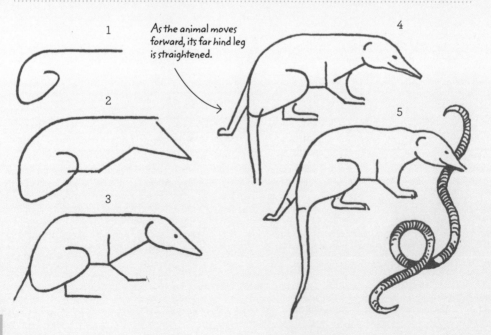

Now you have a go!

MOLES

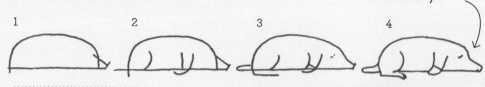

Put in a tiny, light semicircle for the closed eye.

1 2 3 4

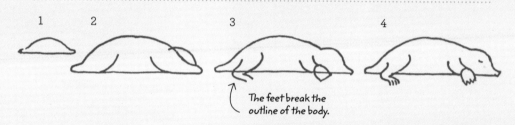

Whiskers give the animal character.

1 2 3 4

1 2 3 4

The feet break the outline of the body.

1 2 3

MOLEHILL

Parapet walk

Exit hole

Room corridor

Bedroom

Now you have a go!

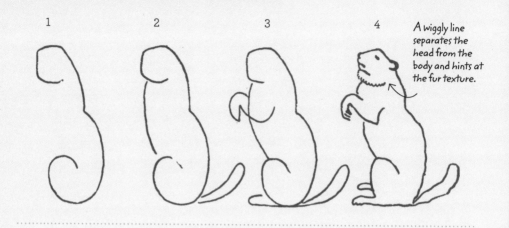

1 2 3 4

A wiggly line separates the head from the body and hints at the fur texture.

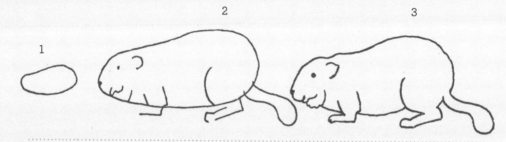

1 2 3

MONGOOSE

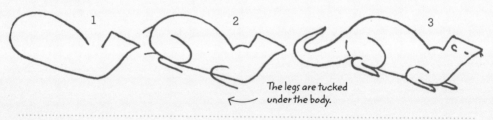

1 2 3

The legs are tucked under the body.

BEAVER

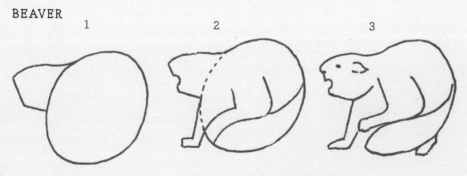

1 2 3

Now you have a go!

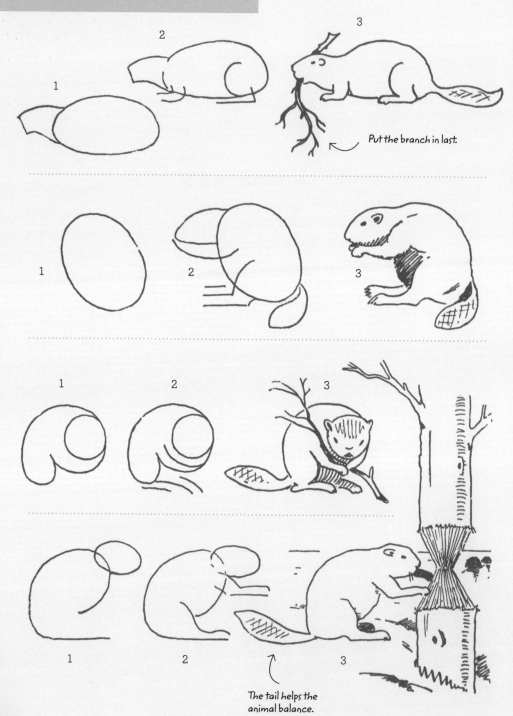

1 2 3

Put the branch in last.

1 2 3

1 2 3

1 2 3

The tail helps the
animal balance.

Now you have a go!

The bushy tail is almost as long as the head and body combined.

1

2

3

1

2

3

4

1

2

3

4

Shade the underside of the body and the far leg to show they're further away.

Now you have a go!

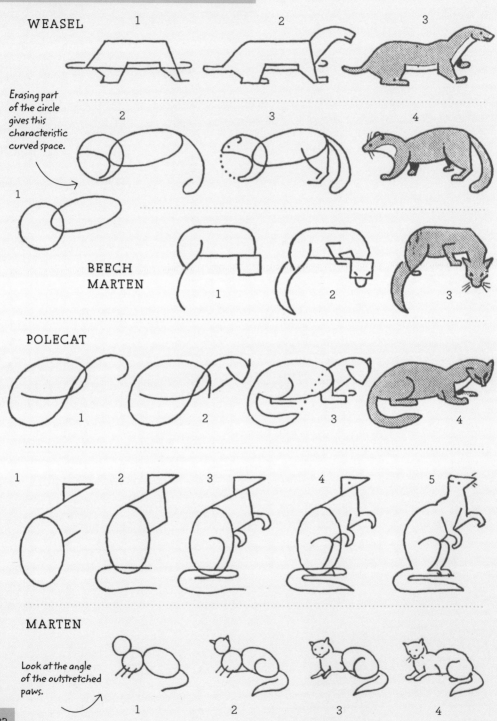

WEASEL 1 2 3

Erasing part of the circle gives this characteristic curved space.

2 3 4

1

BEECH MARTEN 1 2 3

POLECAT 1 2 3 4

1 2 3 4 5

MARTEN

Look at the angle of the outstretched paws.

1 2 3 4

Now you have a go!

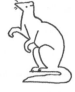

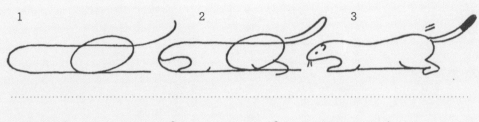

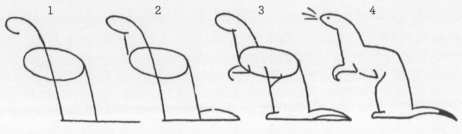

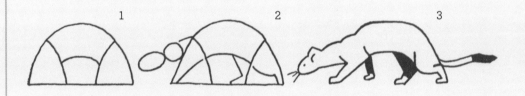

SABLE

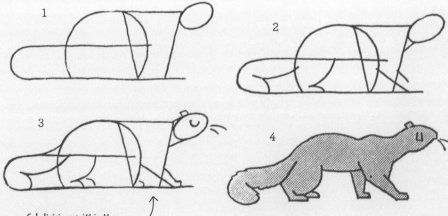

Subdivisions within the initial basic shapes create the separate limbs.

Now you have a go!

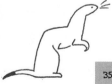

HOW SMALL CARNIVORES ATTACK CHICKEN EGGS

 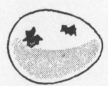

The ermine makes a small hole

The weasel makes several holes

The beech marten makes a larger hole

The polecat makes a big hole

EGG SHAPES

Spherical Oval Regular Conical Elliptical Cylindrical

EGG DIMENSIONS

According to our calculations, a chicken egg is 330 times larger than a hummingbird egg and 25 times smaller than an ostrich egg (which contains up to 1 and a half liters).

 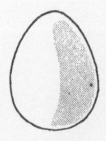

Chicken Ostrich

Now you have a go!

HEDGEHOGS AND PORCUPINES

HEDGEHOGS

Diametrically opposing legs move at the same time—far front and near hind legs first; then near front and far hind legs.

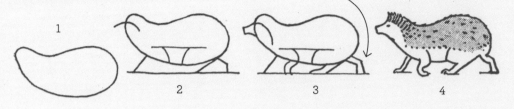

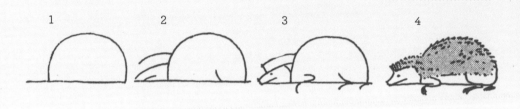

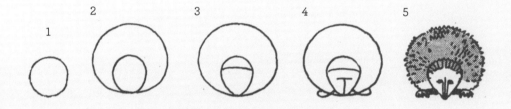

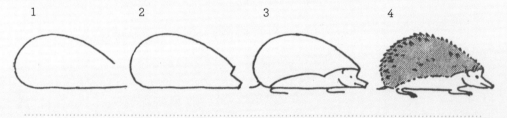

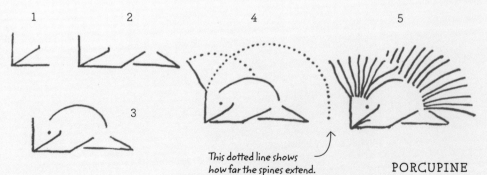

This dotted line shows how far the spines extend.

PORCUPINE

Now you have a go!

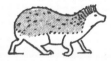

Head-on view—concentric circles;
back view—a pear shape.

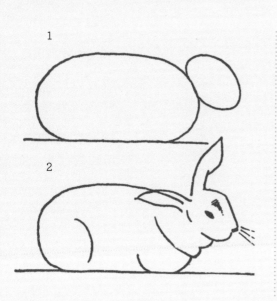

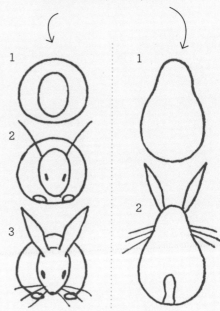

From this side-on
viewpoint, the head
overlaps the body.

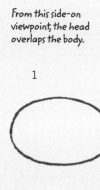

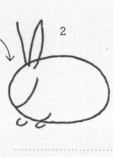

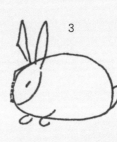

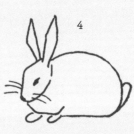

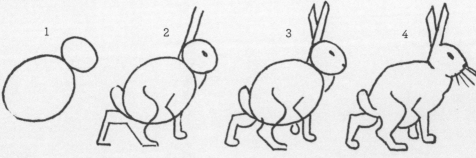

Now you have a go!

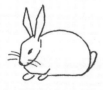

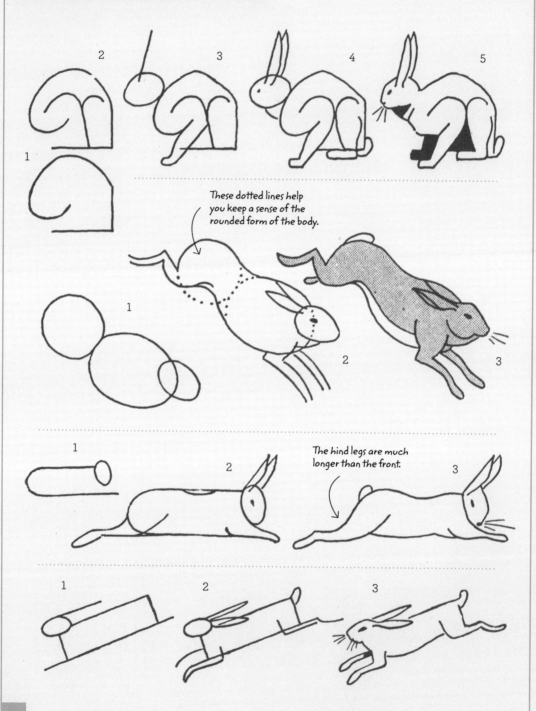

These dotted lines help you keep a sense of the rounded form of the body.

The hind legs are much longer than the front.

Now you have a go!

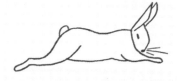

The classic fox head shape starts off as a hexagon.

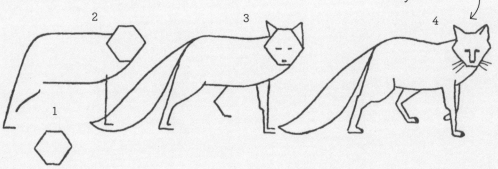

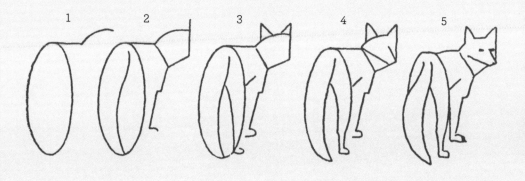

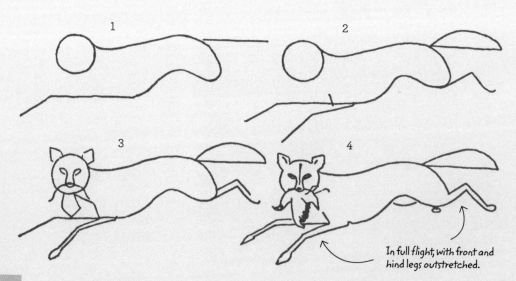

In full flight, with front and hind legs outstretched.

Now you have a go!

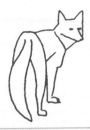

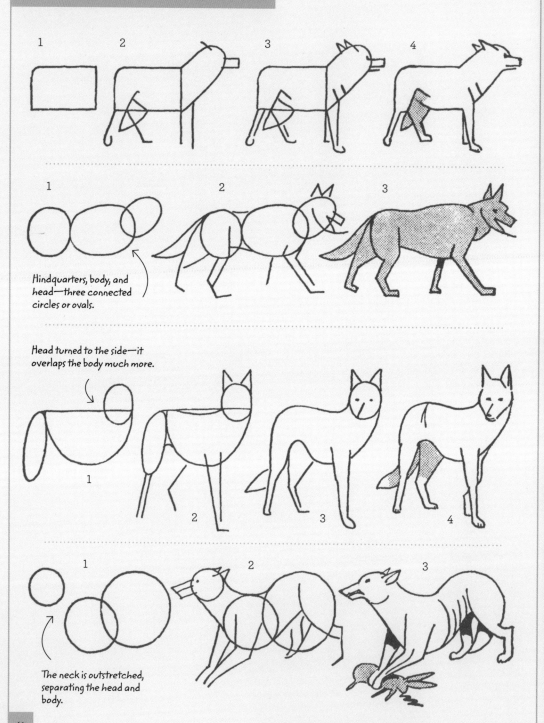

Hindquarters, body, and head—three connected circles or ovals.

Head turned to the side—it overlaps the body much more.

The neck is outstretched, separating the head and body.

Now you have a go!

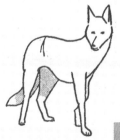

POLAR BEAR

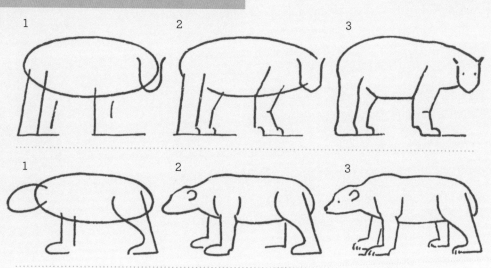

1 2 3

1 2 3

BROWN BEAR

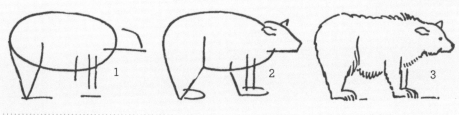

1 2 3

GRIZZLY

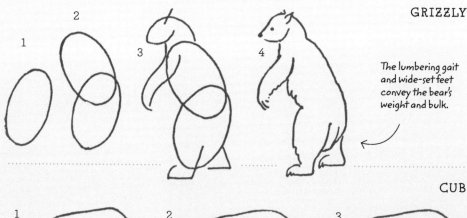

1 2 3 4

The lumbering gait and wide-set feet convey the bear's weight and bulk.

CUB

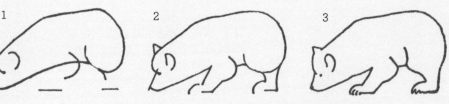

1 2 3

Now you have a go!

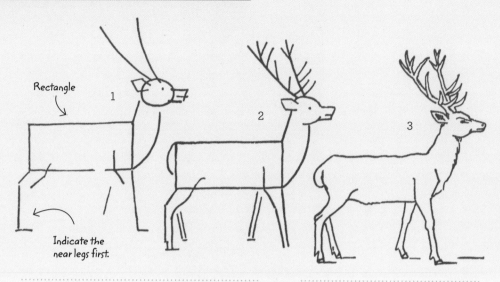

Rectangle

1

Indicate the near legs first.

2

3

DEER

1

Oval

2

3

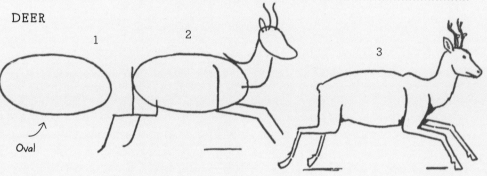

REINDEER

The legs take up roughly the same amount of space as the body.

2

1

3

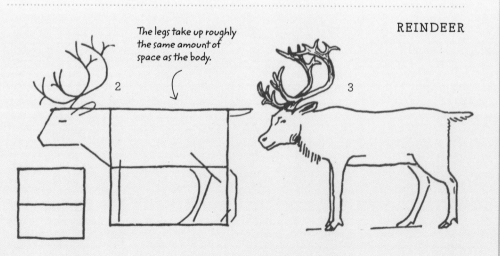

Now you have a go!

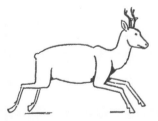

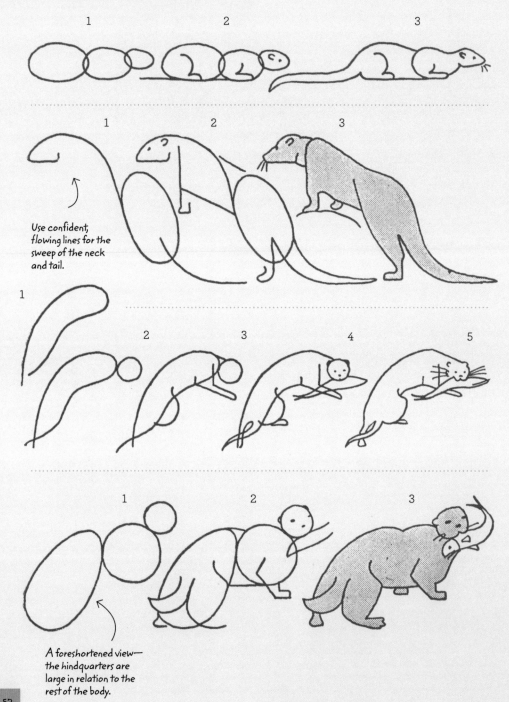

1 2 3

1 2 3

Use confident,
flowing lines for the
sweep of the neck
and tail.

1

2 3 4 5

1 2 3

A foreshortened view—
the hindquarters are
large in relation to the
rest of the body.

Now you have a go!

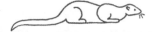

Four "fingers" on the front legs, five "toes" on the back.

1 2 3 4

1 2 3 4

1 2 3 4

Sitting upright, the frog's body slopes at a 45° angle.

1 2 3 4

Viewed from underneath, the eyes and mouth appear very close together.

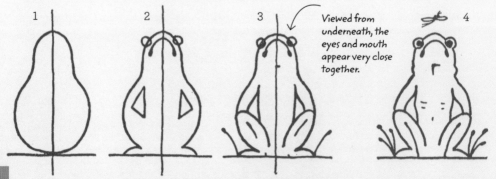

Now you have a go!

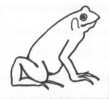

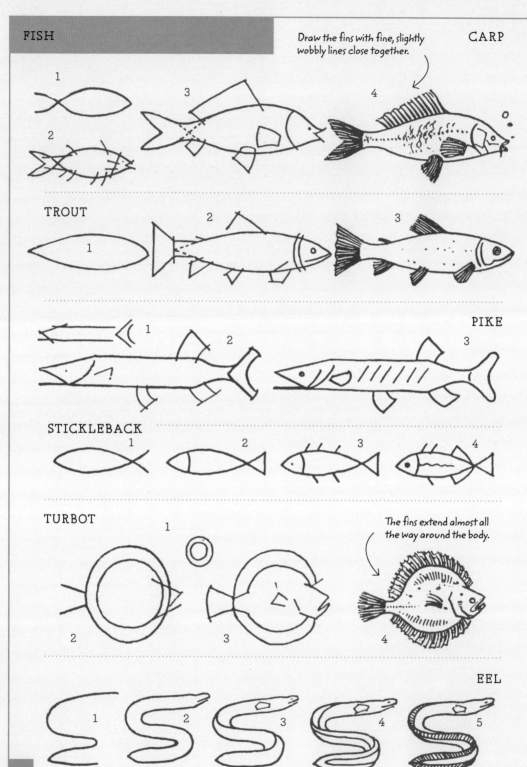

CARP

Draw the fins with fine, slightly wobbly lines close together.

1
2
3
4

TROUT

1
2
3

PIKE

1
2
3

STICKLEBACK

1
2
3
4

TURBOT

1
2
3

The fins extend almost all the way around the body.

4

EEL

1
2
3
4
5

Now you have a go!

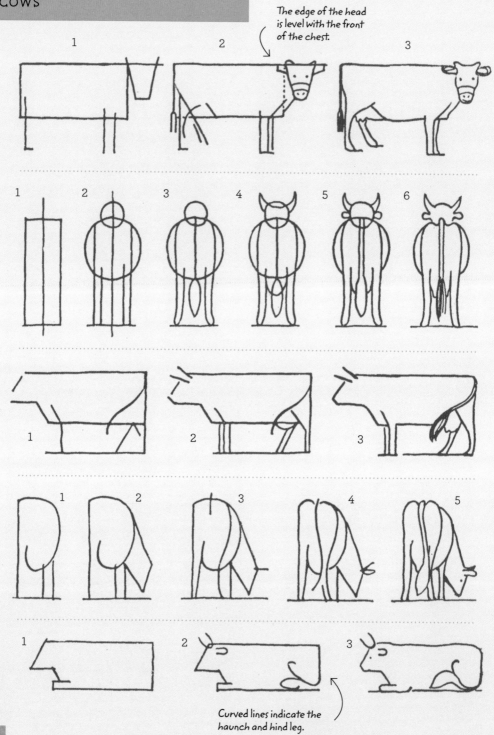

The edge of the head is level with the front of the chest.

Curved lines indicate the haunch and hind leg.

Now you have a go!

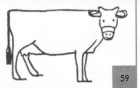

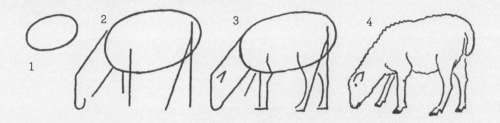

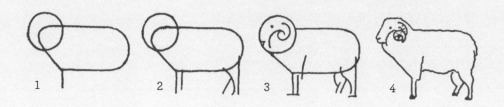

GOAT

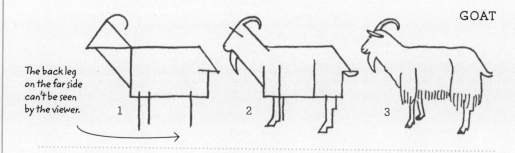

The back leg on the far side can't be seen by the viewer.

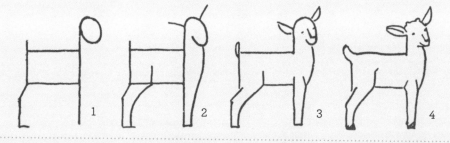

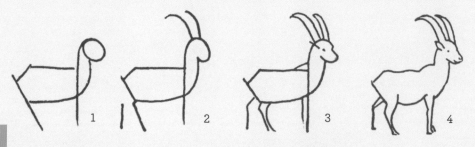

Now you have a go!

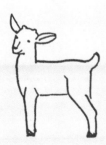

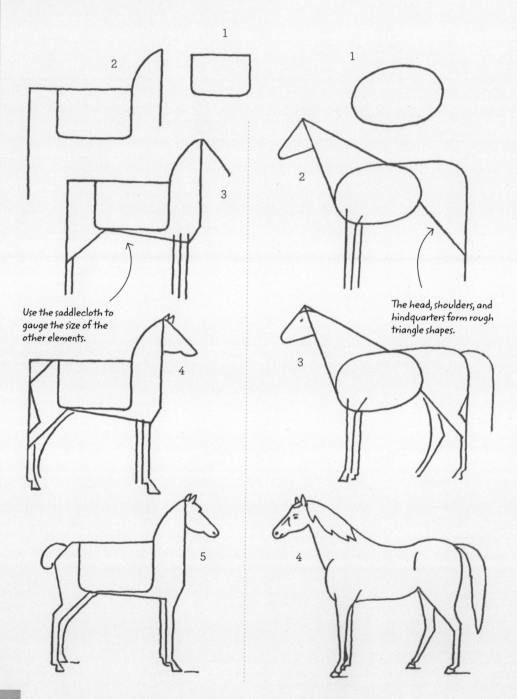

1

2

1

2

3

Use the saddlecloth to gauge the size of the other elements.

The head, shoulders, and hindquarters form rough triangle shapes.

3

4

4

5

Now you have a go!

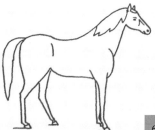

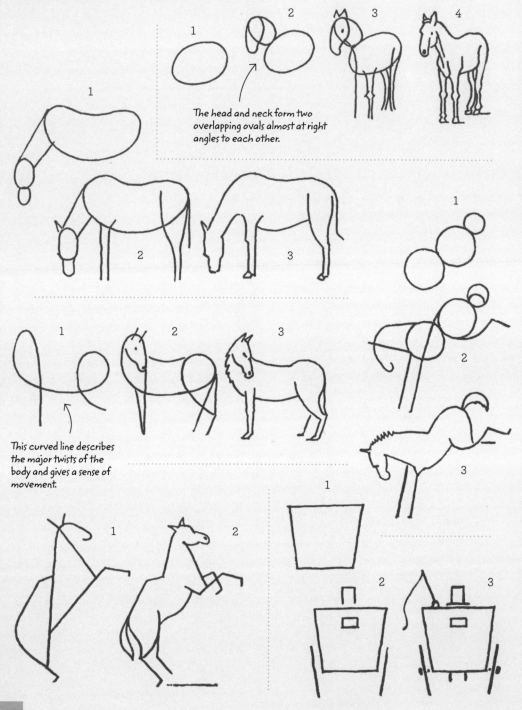

The head and neck form two overlapping ovals almost at right angles to each other.

This curved line describes the major twists of the body and gives a sense of movement.

Now you have a go!

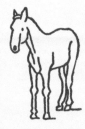

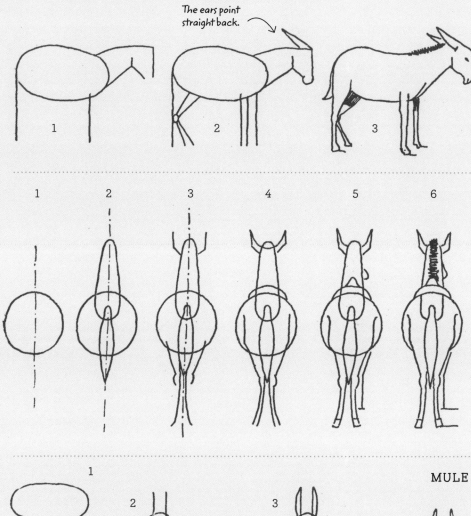

The ears point straight back.

1

2

3

1 2 3 4 5 6

MULE

1

2

3

4

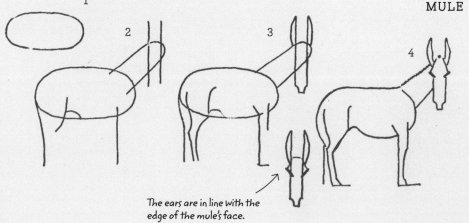

The ears are in line with the edge of the mule's face.

Now you have a go!

PIGS AND BOARS

PIG

Add shading on the underside and back legs.

1

2

3

Three circles form the basis of this front-on pose.

1 2 3 4

1 2 3

BOAR

Get this shape right and the rest will follow.

1 2 3

Now you have a go!

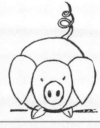

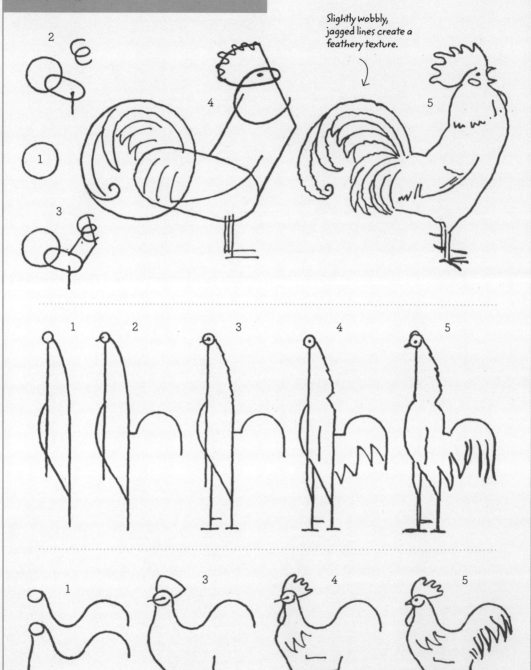

Slightly wobbly, jagged lines create a feathery texture.

Now you have a go!

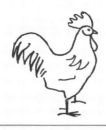

ROOSTERS AND HENS

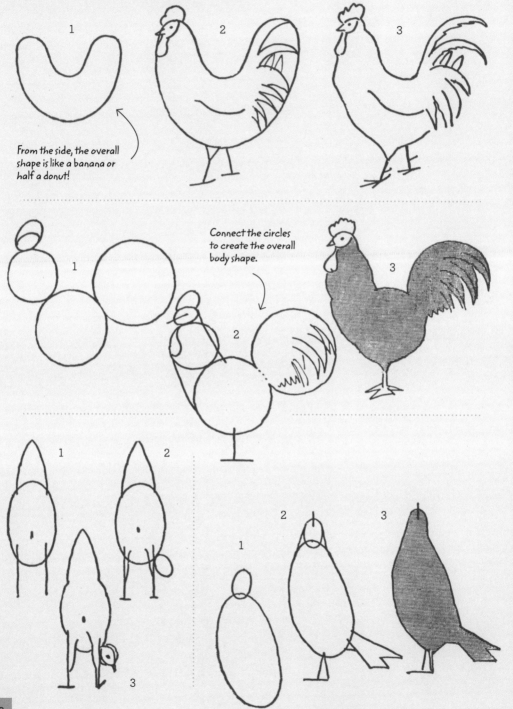

From the side, the overall shape is like a banana or half a donut!

Connect the circles to create the overall body shape.

Now you have a go!

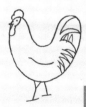

A small, curved line across the body suggests the wing.

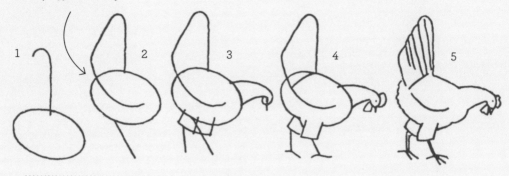

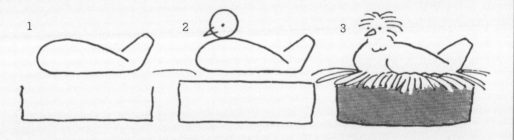

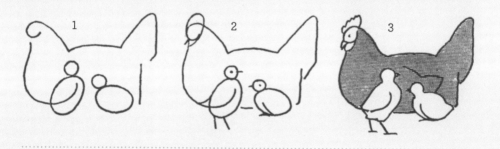

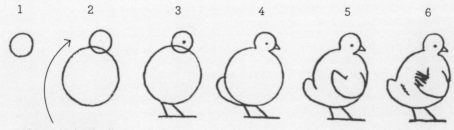

The head is slightly off-centered, not directly above the body.

Now you have a go!

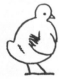

Small dots and fine lines convey both tone and texture in the feathers.

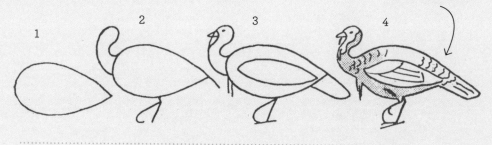

1 2 3 4

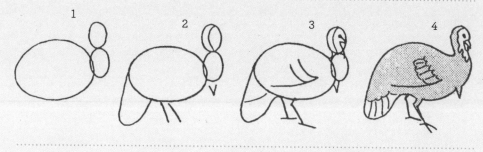

1 2 3 4

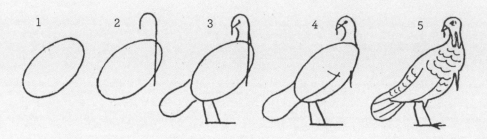

1 2 3 4 5

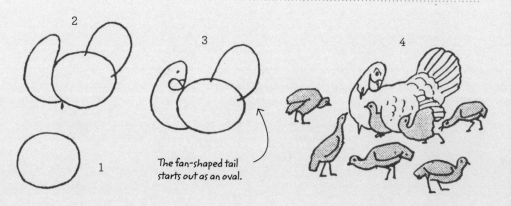

2

1

3

The fan-shaped tail starts out as an oval.

4

TURKEY CHICKS

Now you have a go!

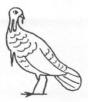

TURKEY

The curved head and tail balance the more angular shape of the body.

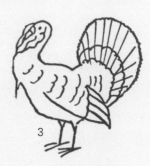

1

2

3

1

2

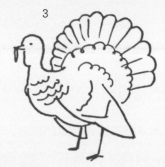

3

The large circle indicates both the body and the tail feathers.

GUINEA FOWL

1 2 3

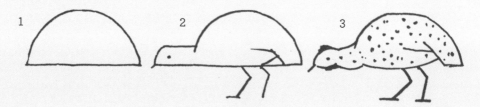

1 2 3

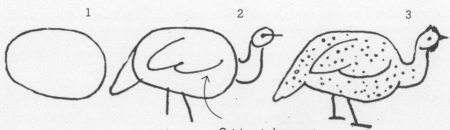

Quick squiggles suggest the head, tail, and wing.

Now you have a go!

The forward-leaning stance shows us the bird is moving.

PARTRIDGE

1 2 3 4

1 2 3 4 5

1 2 3 4 5

QUAIL

1 2 3

1 2 3 4

Now you have a go!

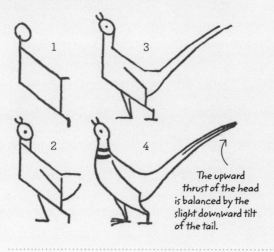

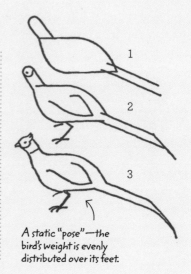

The upward thrust of the head is balanced by the slight downward tilt of the tail.

A static "pose"—the bird's weight is evenly distributed over its feet.

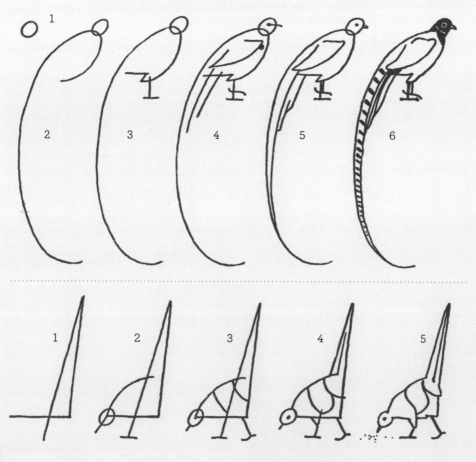

Now you have a go!

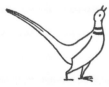

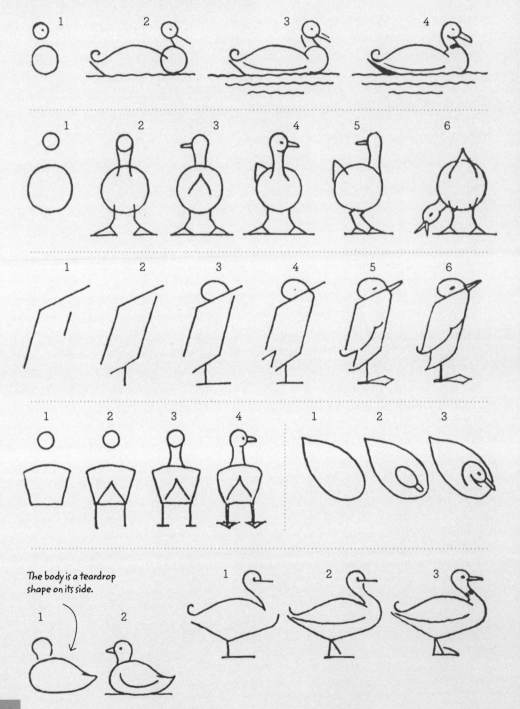

The body is a teardrop shape on its side.

Now you have a go!

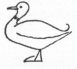

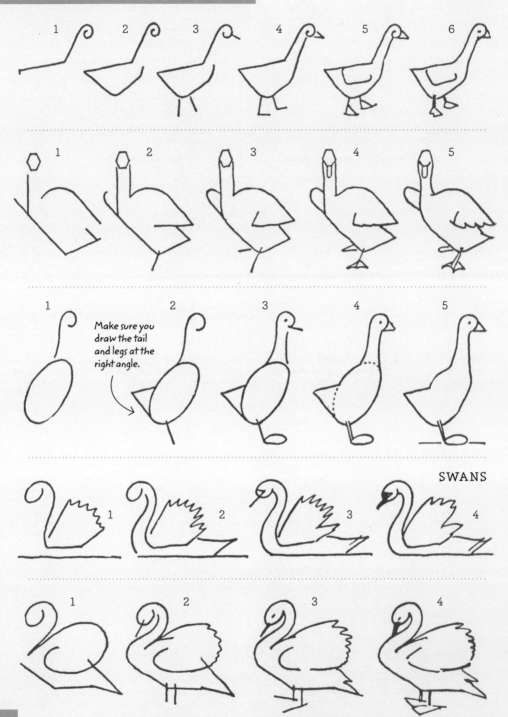

Make sure you draw the tail and legs at the right angle.

SWANS

Now you have a go!

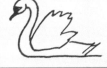

HORNED OWL

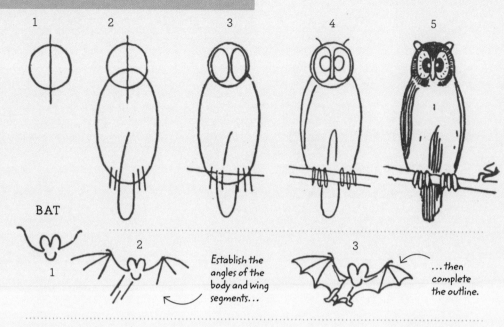

1 2 3 4 5

BAT

1 2 *Establish the angles of the body and wing segments...* 3 *...then complete the outline.*

BARN OWL

1 2 3 4 5

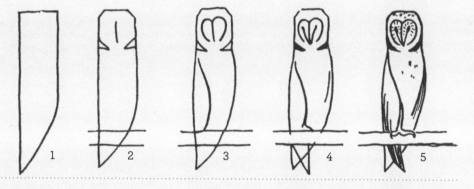

LONG-EARED OWL

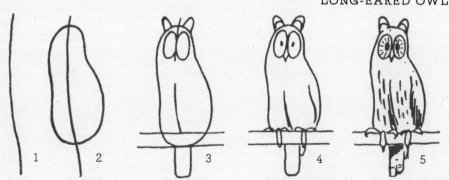

1 2 3 4 5

Now you have a go!

Bold, curved lines give a
feeling of movement.

1 2 3

1 2 3 4 5

3 4 5

1 2

1 2 3 4

Start with the
nest the bird is
clinging to.

Now you have a go!

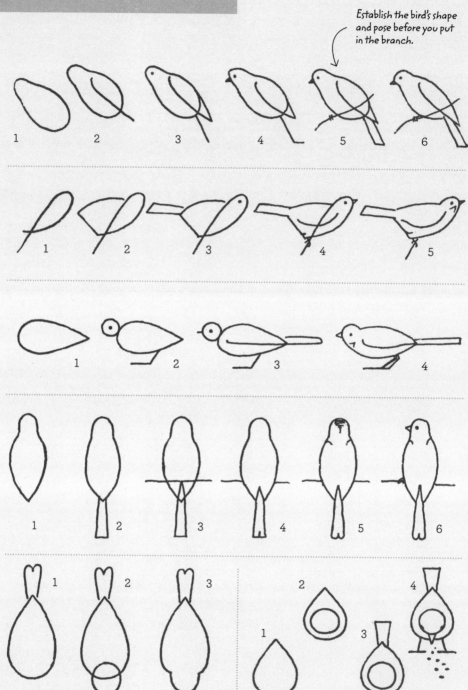

Establish the bird's shape and pose before you put in the branch.

Now you have a go!

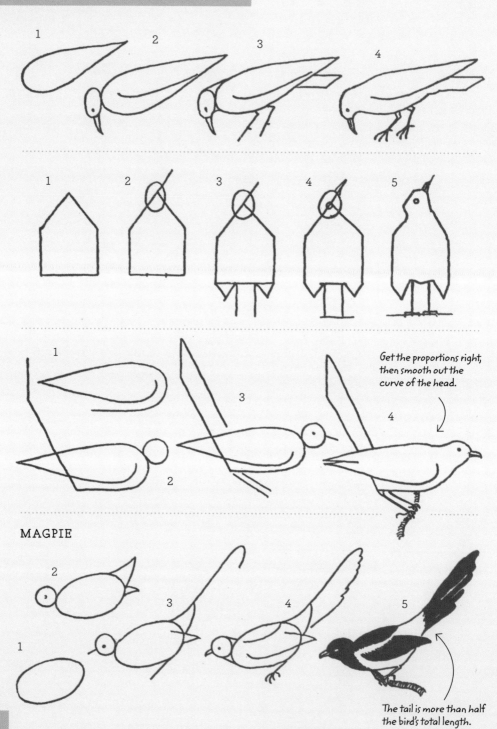

Get the proportions right, then smooth out the curve of the head.

MAGPIE

The tail is more than half the bird's total length.

Now you have a go!

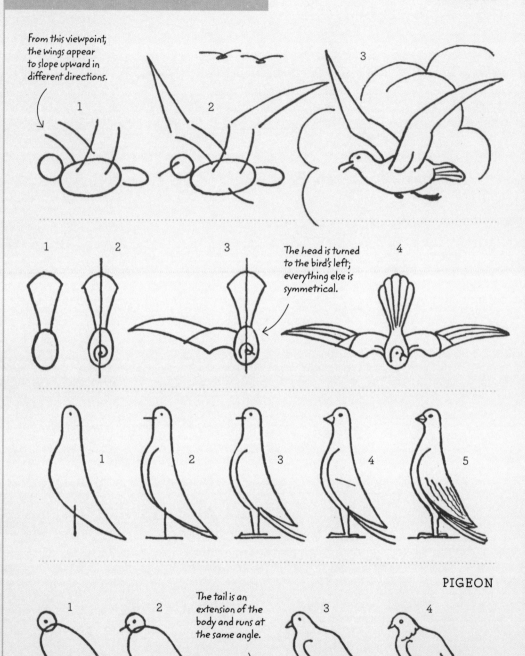

From this viewpoint, the wings appear to slope upward in different directions.

1

2

3

1 2 3 The head is turned to the bird's left; everything else is symmetrical. 4

1 2 3 4 5

PIGEON

1 2 The tail is an extension of the body and runs at the same angle. 3 4

Now you have a go!

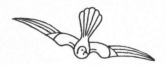

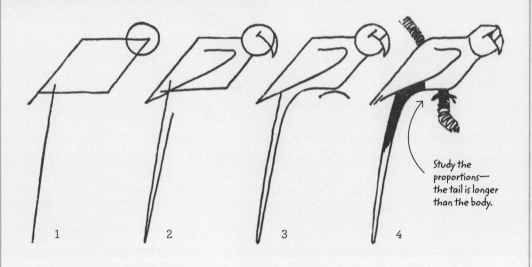

Study the proportions—the tail is longer than the body.

1 2 3 4

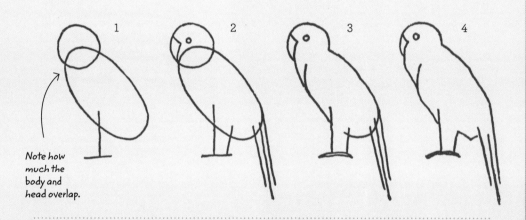

Note how much the body and head overlap.

1 2 3 4

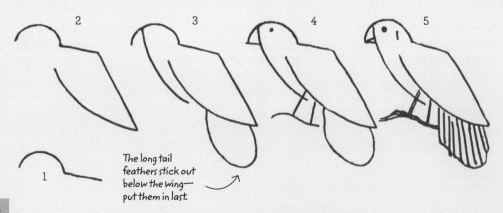

The long tail feathers stick out below the wing—put them in last.

1 2 3 4 5

Now you have a go!

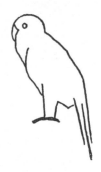

MACAW

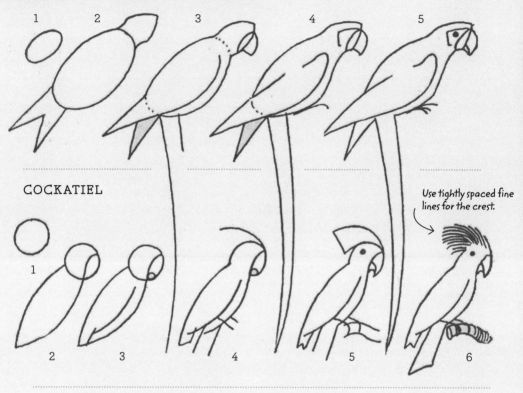

1 2 3 4 5

COCKATIEL

Use tightly spaced fine lines for the crest.

1

2 3 4 5 6

ARA

About-to-take-flight pose.

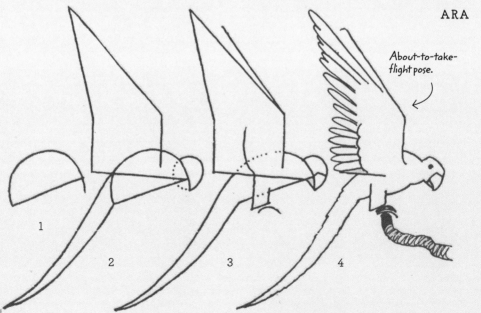

1 2 3 4

Now you have a go!

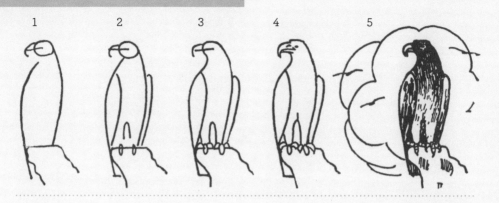

HAWK

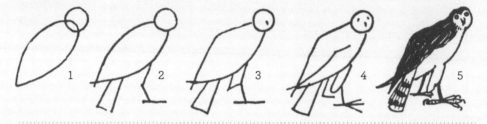

VULTURE

A typical hunched vulture pose—the head and shoulders are level.

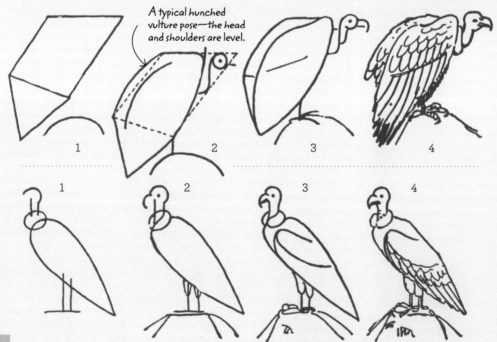

Now you have a go!

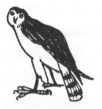

Get the angle of the neck right and everything else will fall into place.

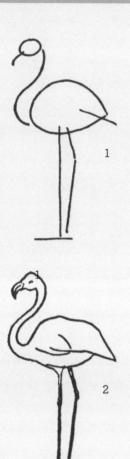

1

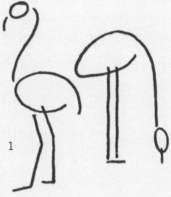

1

2

2

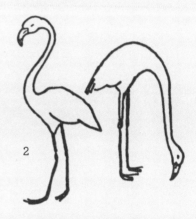

Where does one leg cross the other? Be sure to make the bent leg long enough.

1

2

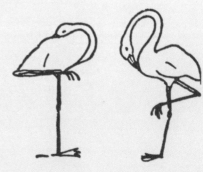

Now you have a go!

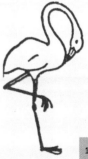

HERON

Keep the feather and crest marks light and thin.

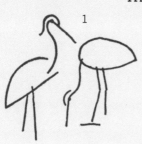 1

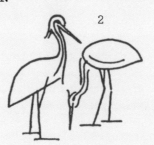 2

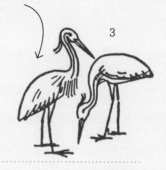 3

STORK

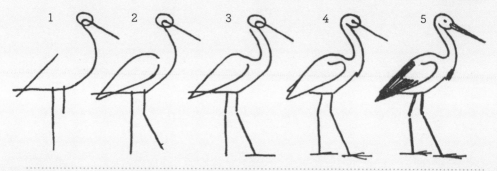

1 2 3 4 5

SNIPE

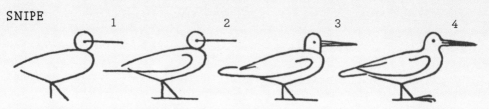

1 2 3 4

MARABOU

The head and body are almost at right angles to each other.

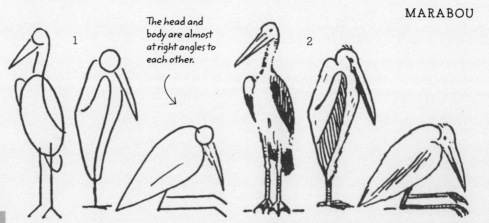

1 2

Now you have a go!

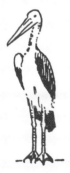

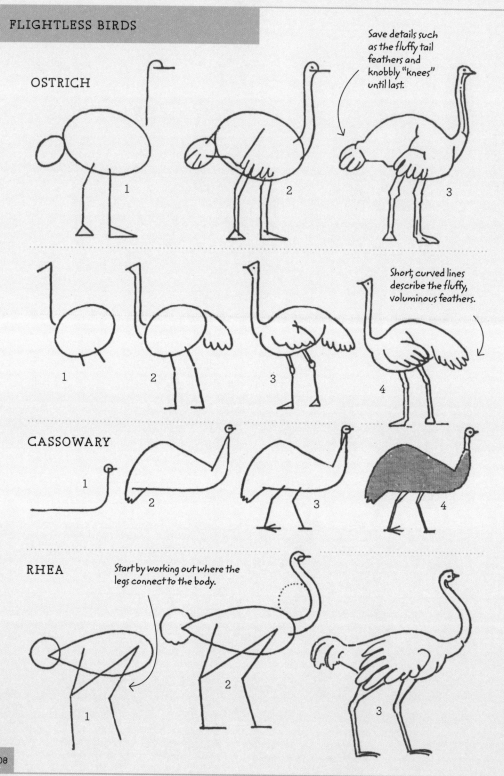

OSTRICH

Save details such
as the fluffy tail
feathers and
knobbly "knees"
until last.

1

2

3

Short, curved lines
describe the fluffy,
voluminous feathers.

1 2 3 4

CASSOWARY

1 2 3 4

RHEA

Start by working out where the
legs connect to the body.

1 2 3

Now you have a go!

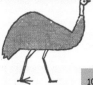

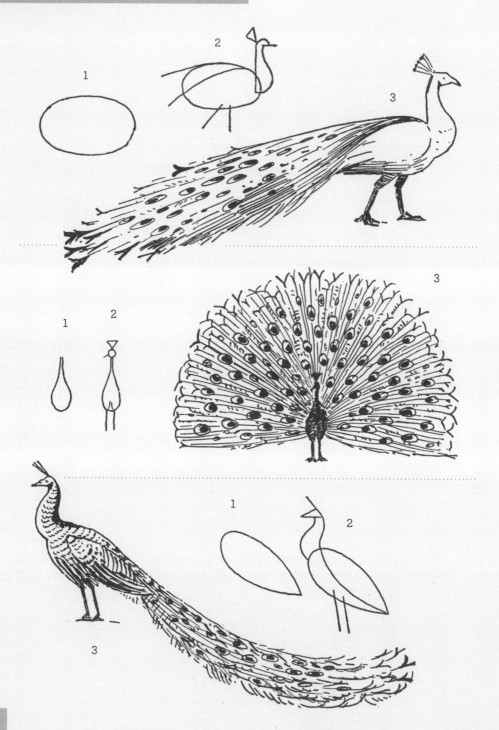

Now you have a go!

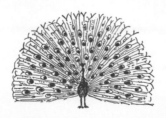

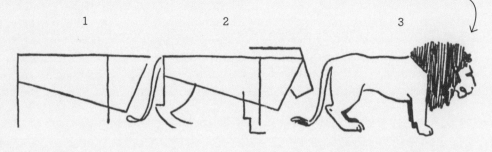

Hatch lines close together for the mane.

1

2

3

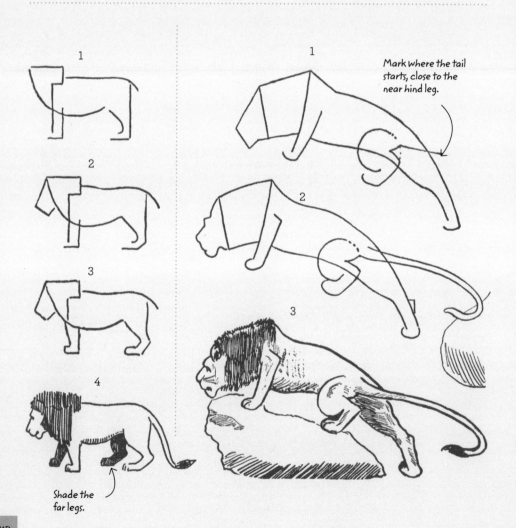

1

2

3

4

1

Mark where the tail starts, close to the near hind leg.

2

3

Shade the far legs.

Now you have a go!

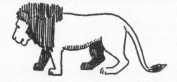

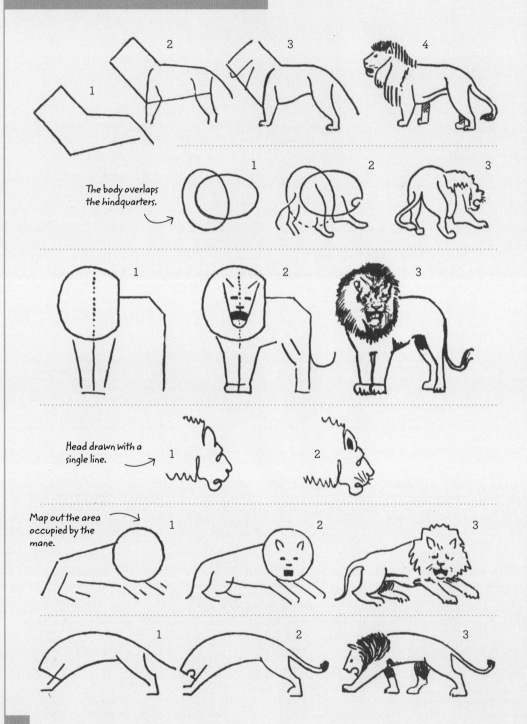

The body overlaps the hindquarters.

Head drawn with a single line.

Map out the area occupied by the mane.

Now you have a go!

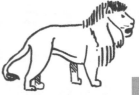

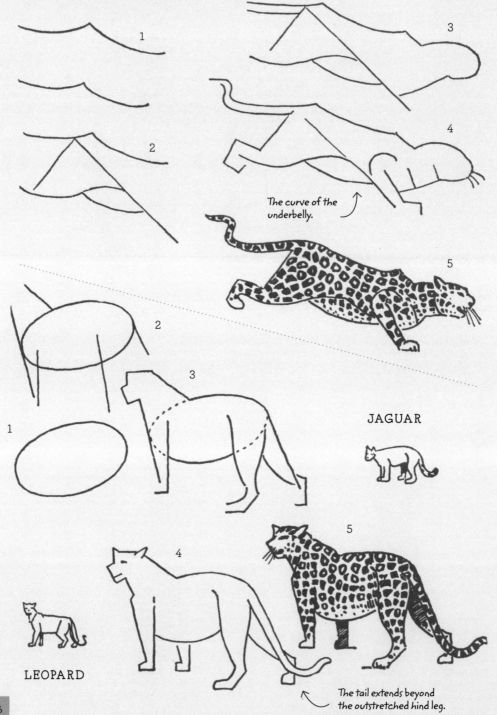

The curve of the underbelly.

JAGUAR

LEOPARD

The tail extends beyond the outstretched hind leg.

Now you have a go!

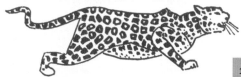

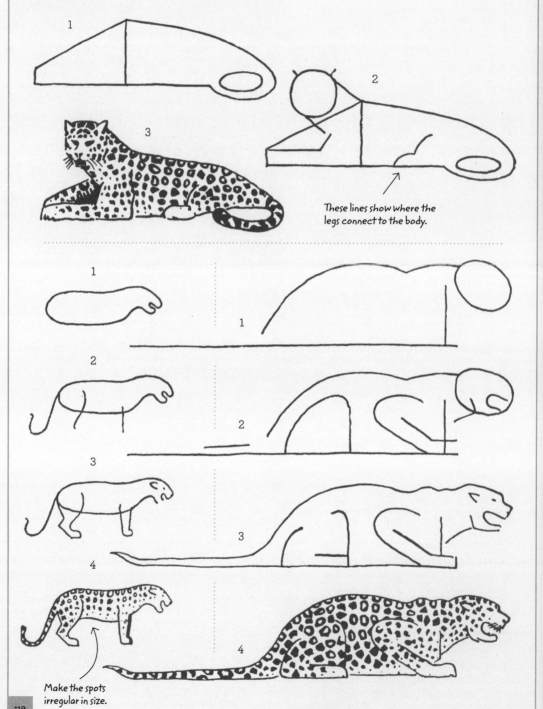

These lines show where the legs connect to the body.

Make the spots irregular in size.

Now you have a go!

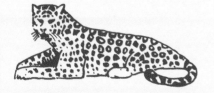

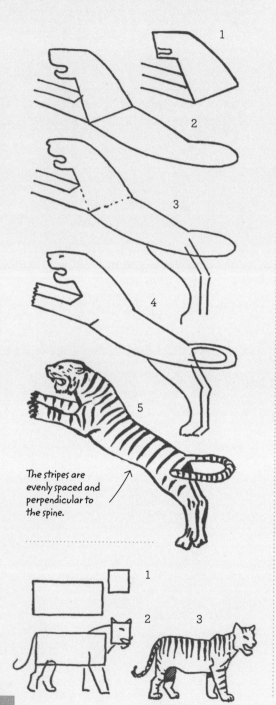

The stripes are evenly spaced and perpendicular to the spine.

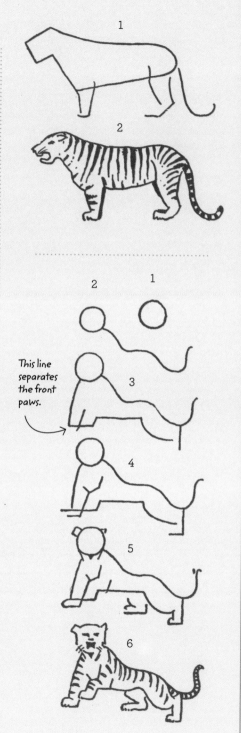

This line separates the front paws.

Now you have a go!

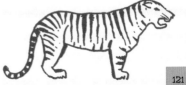

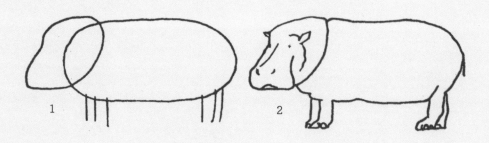

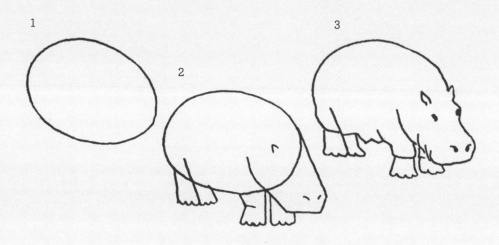

Start with the dominant feature—the head.

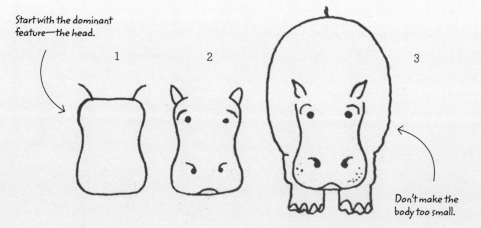

Don't make the body too small.

Now you have a go!

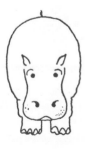

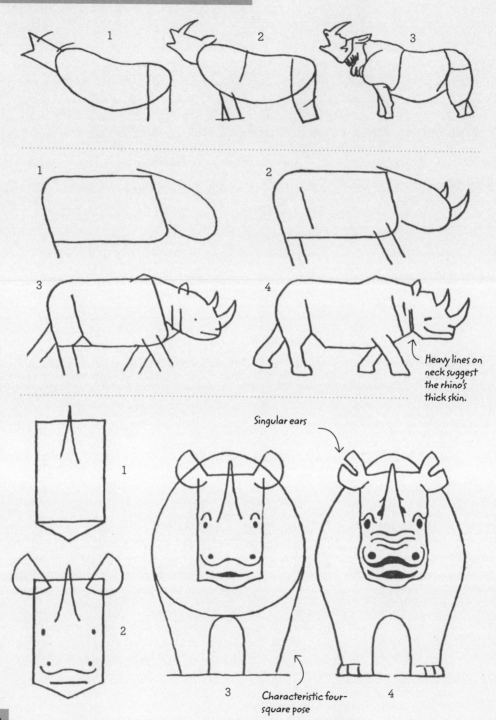

Heavy lines on neck suggest the rhino's thick skin.

Singular ears

Characteristic four-square pose

Now you have a go!

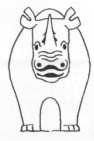

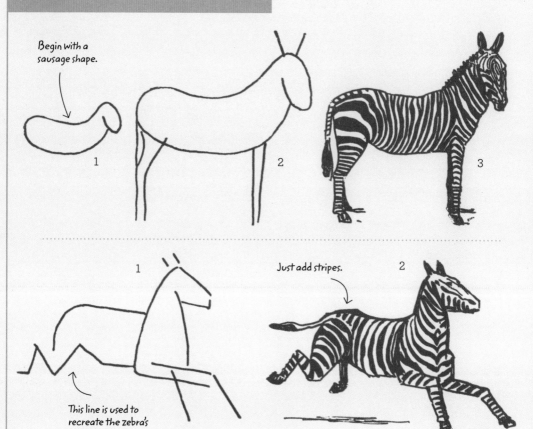

Begin with a sausage shape.

1

2

3

1

This line is used to recreate the zebra's distinctive gait.

Just add stripes.

2

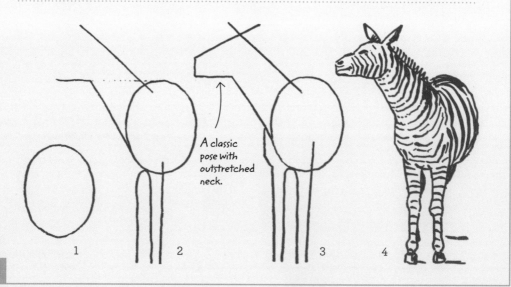

1

2

A classic pose with outstretched neck.

3

4

Now you have a go!

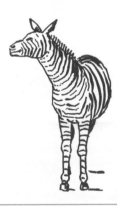

CHIMPANZEE

1 2 3 4

MARMOSET

 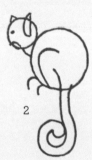 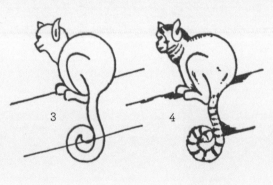

1 2 3 4

GIBBON

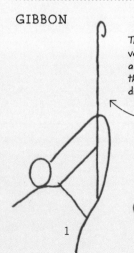

The tail is completely vertical, bearing all the animal's weight, while the limbs splay out in different directions.

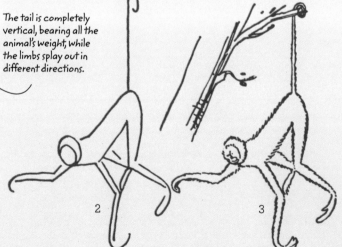

1 2 3

Now you have a go!

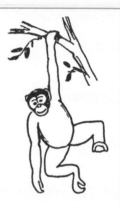

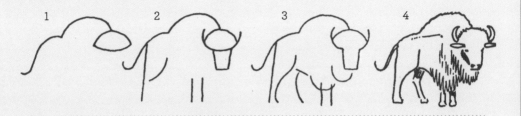

The hump shape is distinctive.

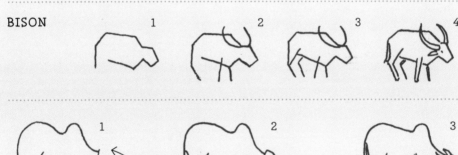

BISON

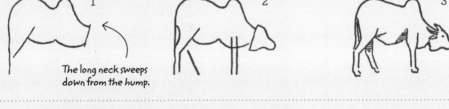

The long neck sweeps down from the hump.

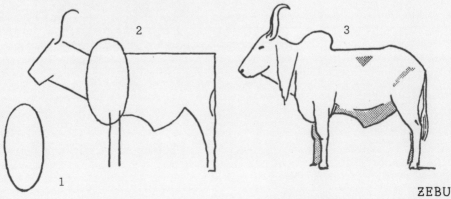

ZEBU

Now you have a go!

The head and body shapes are almost at right angles to each other.

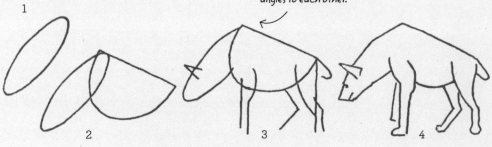

1

2

3

4

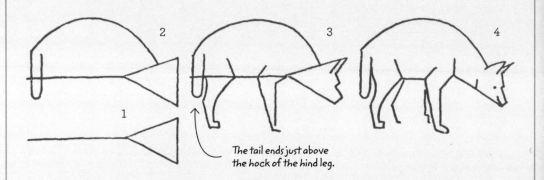

2

1

3

4

The tail ends just above the hock of the hind leg.

JACKALS

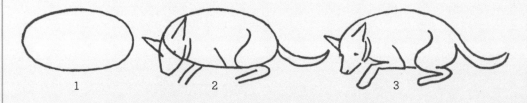

1

2

3

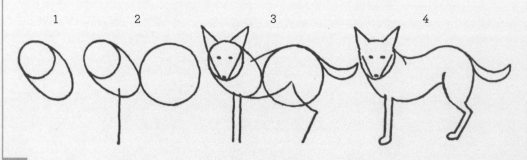

1

2

3

4

Now you have a go!

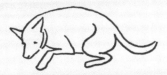

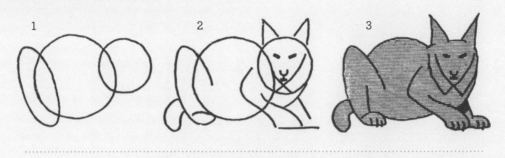

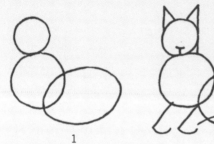

In this semi-upright pose, the chest is larger than you might expect.

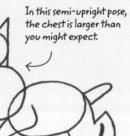

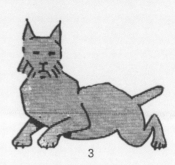

CHEETAH

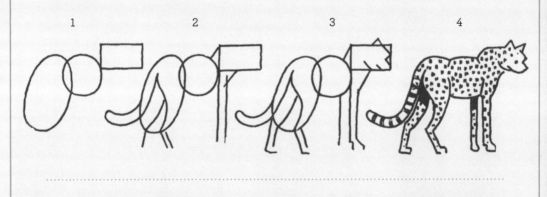

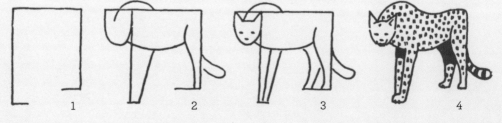

Now you have a go!

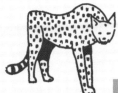

ANTELOPE

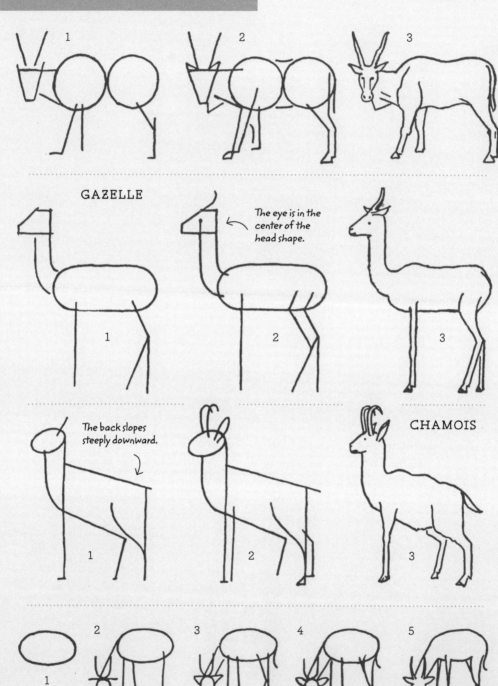

GAZELLE

The eye is in the center of the head shape.

The back slopes steeply downward.

CHAMOIS

Now you have a go!

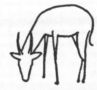

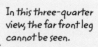

In this three-quarter view, the far front leg cannot be seen.

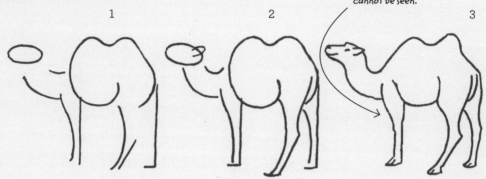

1 2 3

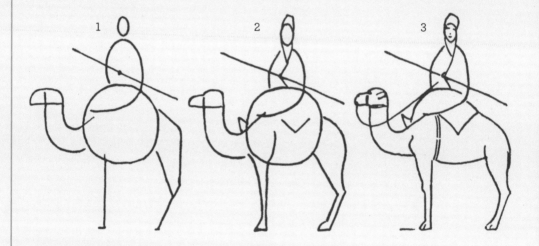

1 2 3

The long neck and body follow the same angle.

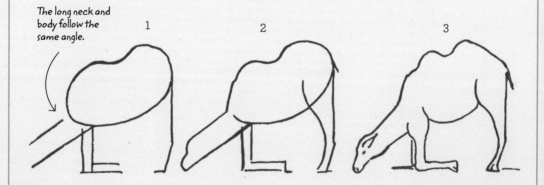

1 2 3

Now you have a go!

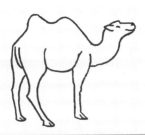

1

2

3

Smooth the triangle of the chest into a more rounded shape.

1

2

3

The front legs are straight; while the hind legs are angled.

1

2

3

Note how foreshortened the hind legs are.

Now you have a go!

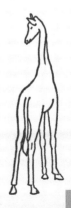

The right foreleg is level with the mid-point of the ear.

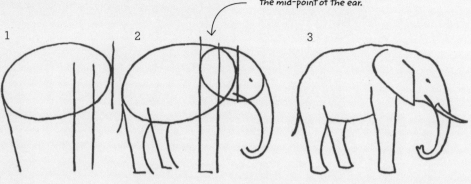

1 2 3

Start with the "negative shape" between the legs.

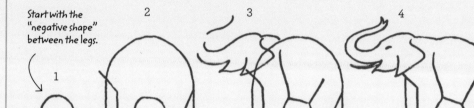

1 2 3 4

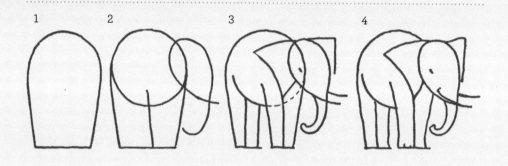

1 2 3 4

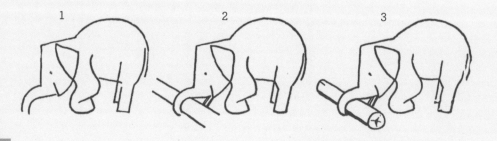

1 2 3

Now you have a go!

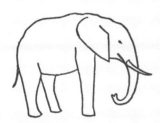

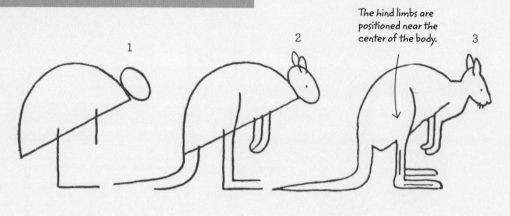

The hind limbs are positioned near the center of the body.

1

2

3

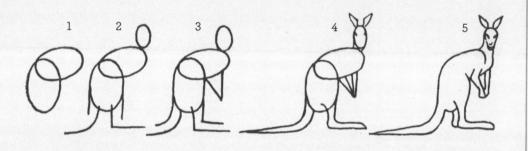

1 2 3 4 5

Semi-upright; the body forms a triangle shape.

2

1

3

4

5

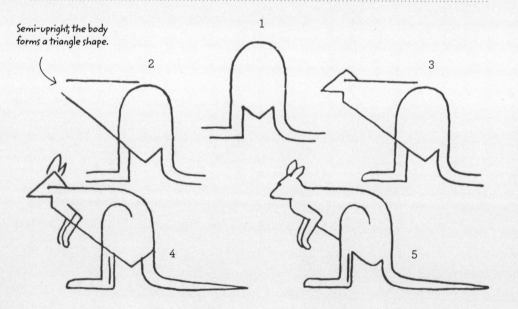

Now you have a go!

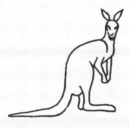

LIZARDS AND CROCODILES

LIZARD

CHAMELEON

ALLIGATOR

CROCODILE

Jagged lines convey the skin texture.

GHARIAL

Note how sharply the jaw tapers.

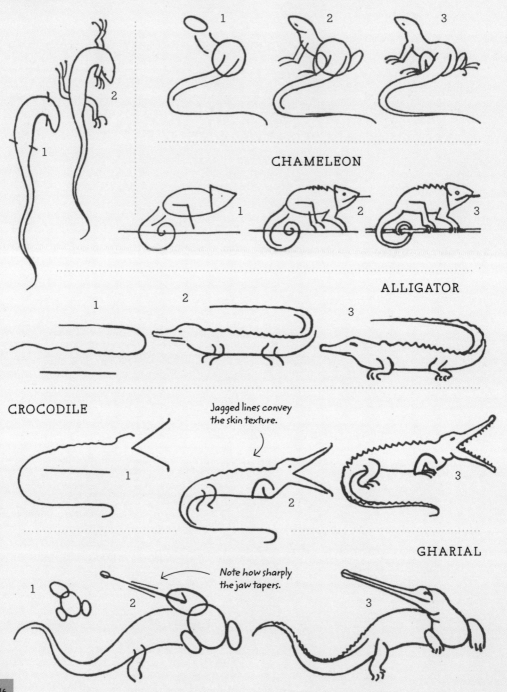

Now you have a go!

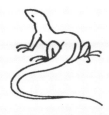

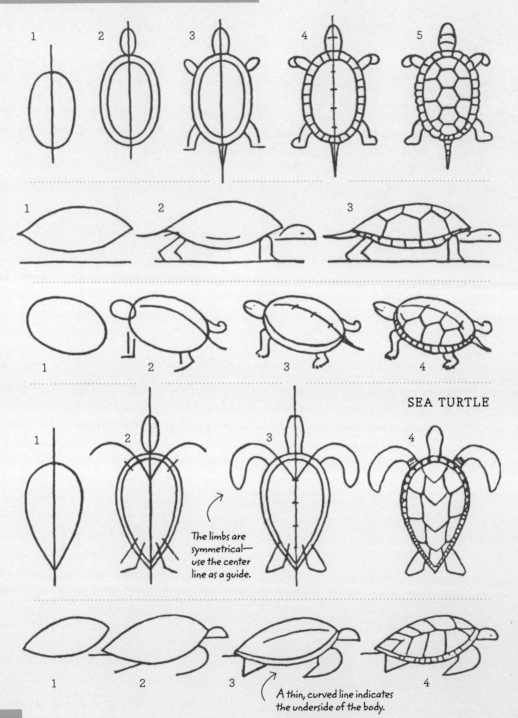

SEA TURTLE

The limbs are symmetrical— use the center line as a guide.

A thin, curved line indicates the underside of the body.

Now you have a go!

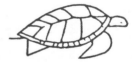

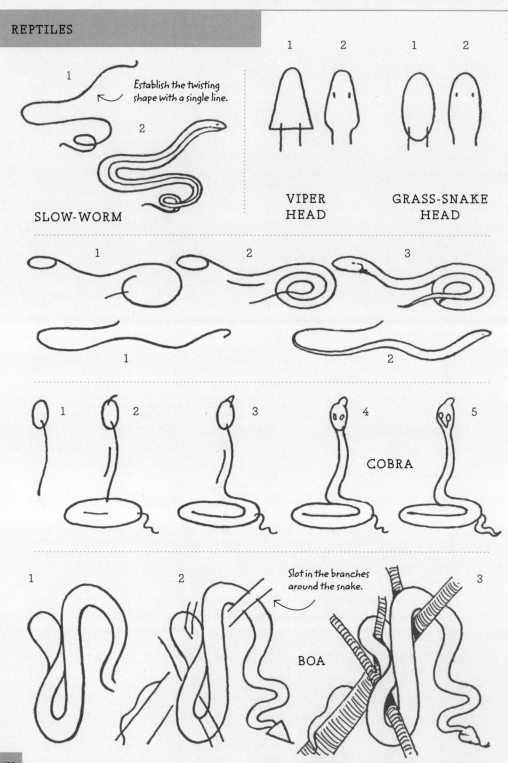

Establish the twisting shape with a single line.

SLOW-WORM

VIPER HEAD

GRASS-SNAKE HEAD

COBRA

Slot in the branches around the snake.

BOA

Now you have a go!

1

2

3

4

1

2

Link the head
and tail with a
sweeping curve.

3

4

5

6

Only half the whale's body
breaks the water surface.

Now you have a go!

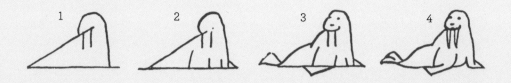

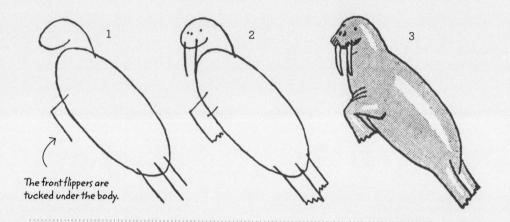

The front flippers are tucked under the body.

WALRUS HEAD

The tiny eyes are in line with the tusks.

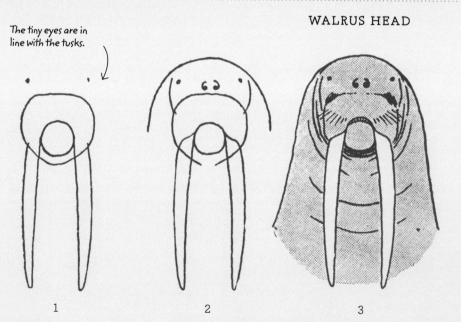

Now you have a go!

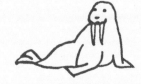

Mark out where the extremities of the body lie, then sketch the body shape within this triangle.

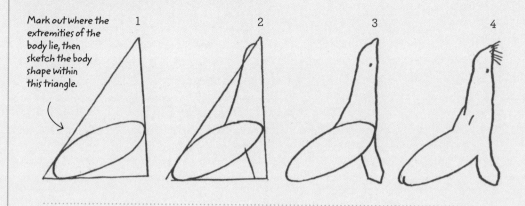

1 2 3 4

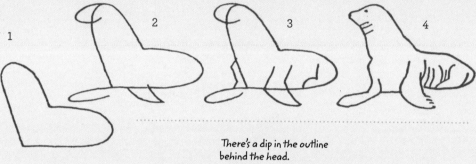

1 2 3 4

There's a dip in the outline behind the head.

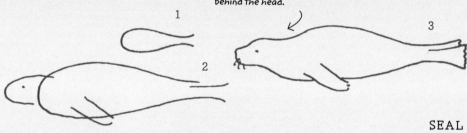

1

2

3

SEAL

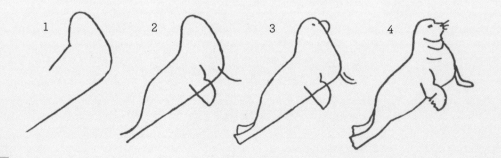

1 2 3 4

Now you have a go!

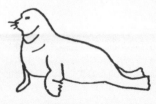

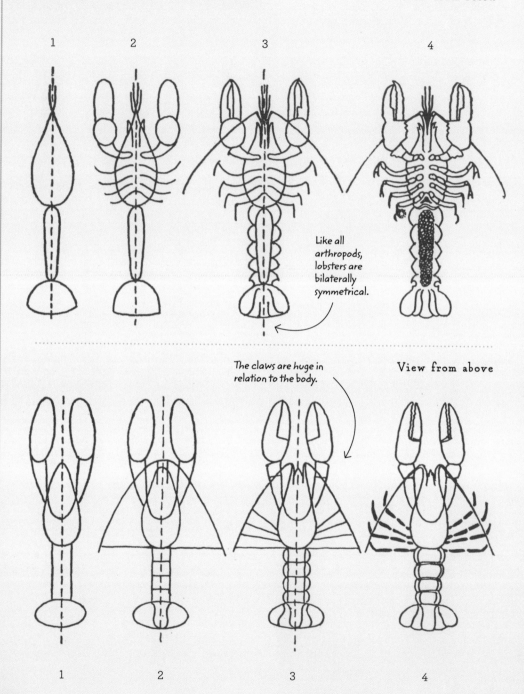

Like all arthropods, lobsters are bilaterally symmetrical.

The claws are huge in relation to the body.

View from above

158

Now you have a go!

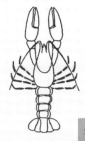

The legs are segmented— use fine lines here.

CRAB

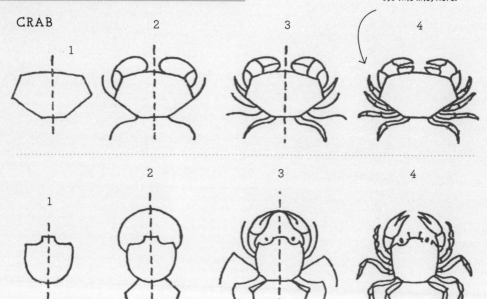

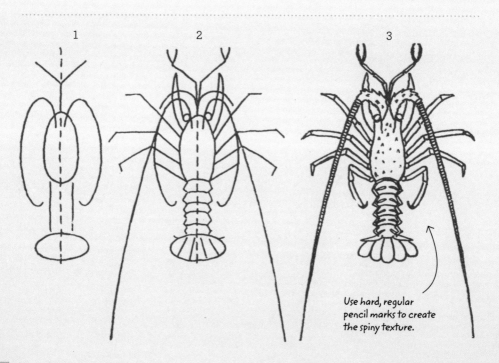

Use hard, regular pencil marks to create the spiny texture.

LANGOUSTINE

Now you have a go!

SNAIL

A few small marks convey the shell's hard texture.

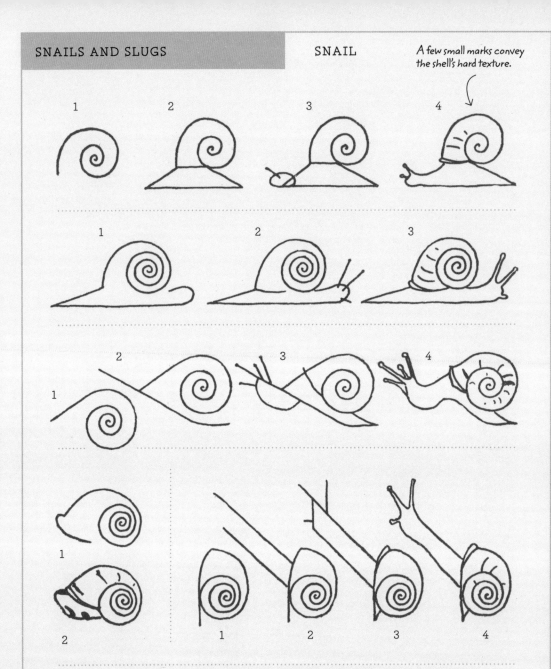

SLUG

Draw an elongated oval for the slug's body.

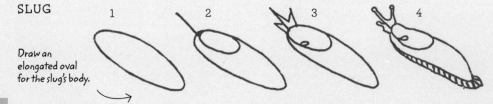

Now you have a go!

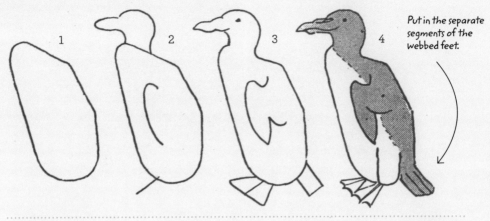

Put in the separate segments of the webbed feet.

1 2 3 4

ROCKHOPPER PENGUIN

1 2 3 4

EMPEROR PENGUIN

This line indicates where the color shifts from black to white.

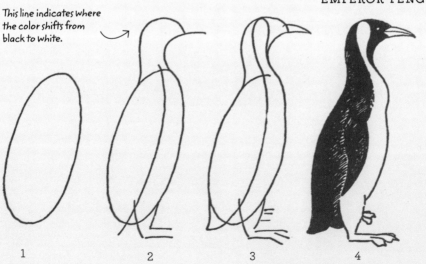

1 2 3 4

Now you have a go!

INSECT SCHEMA

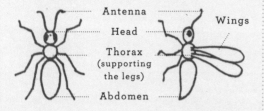

Antenna

Head

Wings

Thorax
(supporting
the legs)

Abdomen

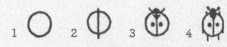

1 2 3 4

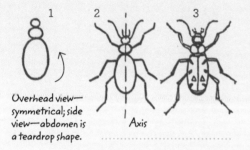

1

2

3

Overhead view—
symmetrical; side
view—abdomen is
a teardrop shape.

Axis

1 2 3 4

Be aware of where
the legs connect to the
abdomen, even though
this area won't be seen.

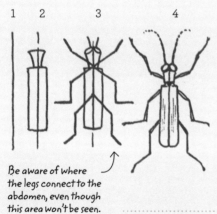

1 2 3

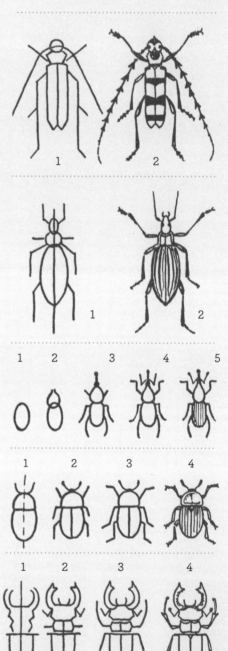

1 2

1 2

1 2 3 4 5

1 2 3 4

1 2 3 4

Now you have a go!

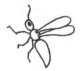

FLY

The three parts of an insect—head, thorax, and abdomen.

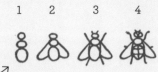

1 2 3 4

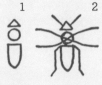

1

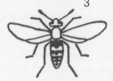

2 3

WASP

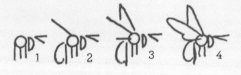

1 2 3 4

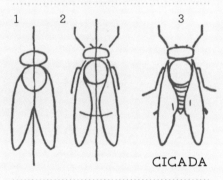

1 2 3

CICADA

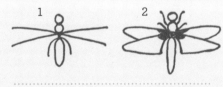

1 2

DRAGONFLY

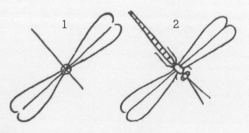

1 2

HOUSE SPIDER

1 2 3 4

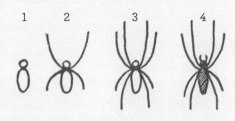

TARANTULA

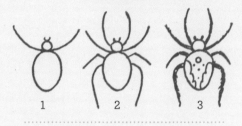

1 2 3

ORB-WEAVER SPIDER

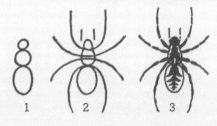

1 2 3

BEE

1 2

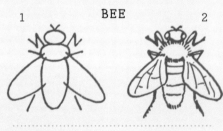

MOSQUITO

1 2

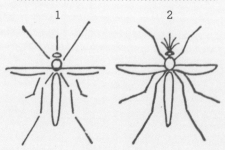

Now you have a go!

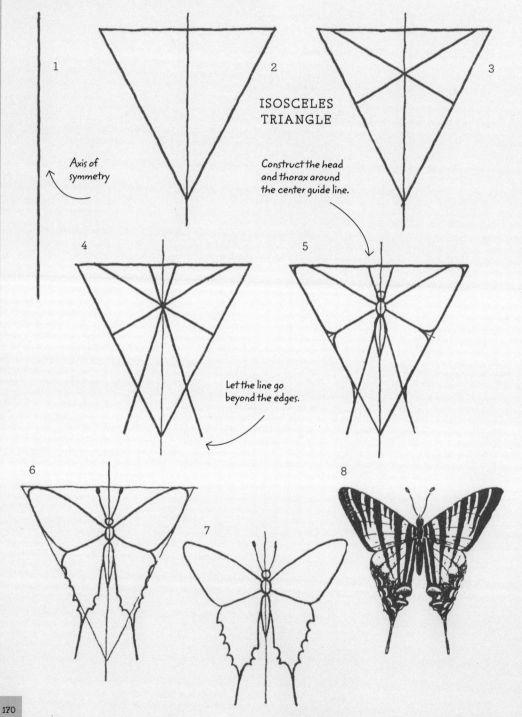

1

2

ISOSCELES
TRIANGLE

3

Axis of
symmetry

Construct the head
and thorax around
the center guide line.

4

5

Let the line go
beyond the edges.

6

7

8

Now you have a go!

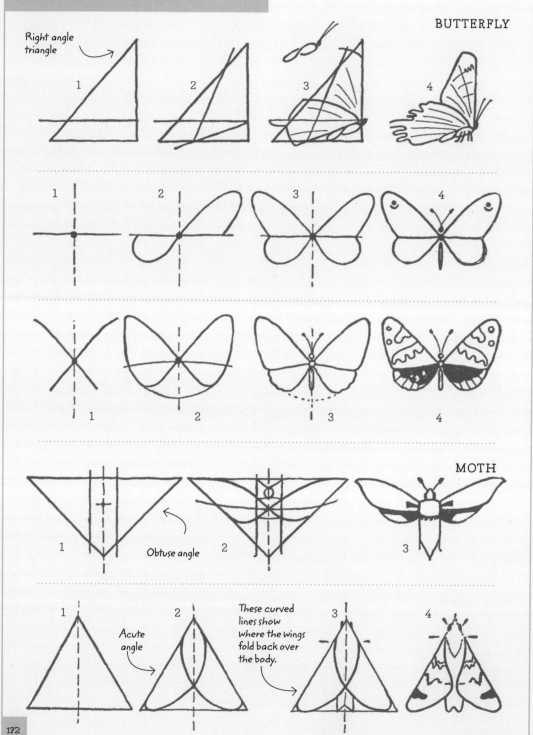

BUTTERFLY

Right angle triangle

1 2 3 4

MOTH

Obtuse angle

Acute angle

These curved lines show where the wings fold back over the body.

Now you have a go!

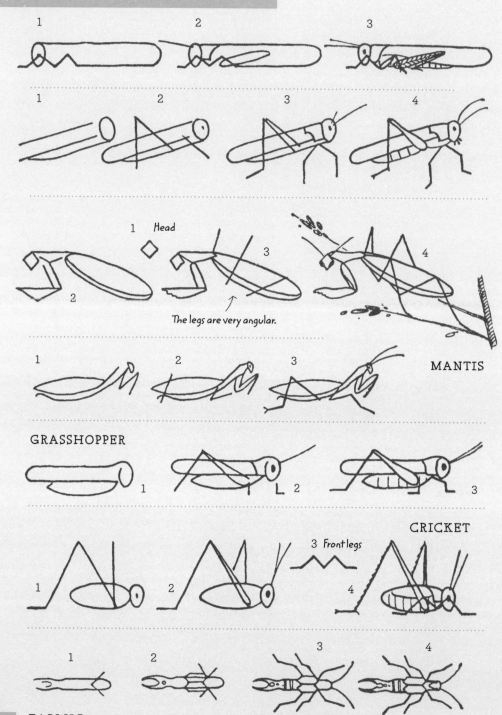

1 2 3

1 2 3 4

1 Head

2

3

4

The legs are very angular.

MANTIS

GRASSHOPPER

1

2

3

CRICKET

3 Front legs

1

2

4

EARWIG

1 2 3 4

Now you have a go!

fin